Landesstelle für die
nichtstaatlichen Museen
in Bayern

ALTER HOF:
THE IMPERIAL CASTLE

in Munich

Deutscher Kunstverlag München Berlin

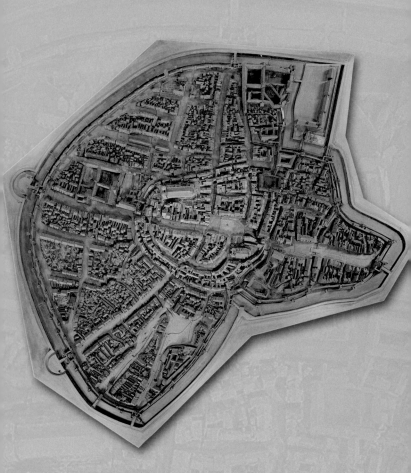

Munich in the Middle Ages, town
model by Jakob Sandtner, 1570.
In colour: the Alter Hof and the area
of the oldest town wall around 1200.
Original in the Bayerisches Nationalmuseum,
Munich

THE IMPERIAL CASTLE IN MUNICH

THE ALTER HOF AS THE FIRST SOVEREIGN'S RESIDENCE IN MUNICH

The Alter Hof is the oldest residence of the Wittelsbach dukes of Bavaria in Munich. It dates back to the 12th century. The complex changed considerably in the centuries, parallel to the development of the city of Munich itself. The close links between the sovereign and the town have been evident in various sectors ever since the Middle Ages:
- in jurisdiction
- in economy and trade
- in church and religion
- in architecture.

They are also reflected in the different symbols in the Munich emblem and coat of arms. In the course of the 16th century, Munich began looking more and more like a royal residence town.

At first, the castle-like complex of the Alter Hof was only used sporadically, before it became the main seat of the Upper Bavarian rulers in the late 13th century. A number of important members of the Wittelsbach family determined its appearance: It was the favourite residence of Duke Ludwig IV, who was elected German king in 1314 and crowned emperor in 1328. Other dukes further expanded and beautified the Alter Hof. In the 16th century, the centre of Wittelsbach rulership was moved to the location of the present residence. The Alter Hof has had a number of different functions since then, including that of the fiscal headquarters of the Bavarian duchy and state.

Ludwig IV, who later became known as Ludwig 'the Bavarian', played an important role in the history of the Alter Hof, as he stood in the centre of European politics for many decades and with him, of course, also his residence. During his reign, the imperial insignia were kept in the St. Lorenzkapelle. The period around 1324–50 can be considered the grandest and most important epoch in the history of the Alter Hof.

HISTORY OF MUNICH

Court and City – The Development of Munich under the Influence of the Wittelsbach Dynasty

Establishment of a Market and Fortification of the Town

1158
Establishment of a market by the Guelph duke of Bavaria, Heinrich der Löwe. The salt trading route from Salzburg to Augsburg intersected the trade route from Italy via Innsbruck to Nuremberg at this point. Munich had around 1000 inhabitants.

Around 1200
The first fortifications were built under the Wittelsbach duke Otto. The outline of the curved town wall is still recognisable in the map of the city centre today. Munich possessed five toll gates: Hinteres Schwabinger Tor, Vorderes Schwabinger Tor, Talburgtor (the only one to have survived), Altes Sendlinger Tor and Kaufinger Tor.

1255
From 1255 the Dukes of Upper Bavaria finally established their residence in Munich, making the city the centre of the Wittelsbach reign. Their castle consisted of a wall, which was part of the town wall, a largish stone building to live in and two wooden buildings – probably utility buildings and workshops.

1271
The Frauenkirche was consecrated in 1271. It was the second parish church in Munich, alongside St. Peter. Even though the citizens had to pay for the construction, the Frauenkirche was also used as a princely court church, where members of the Wittelsbach dynasty were buried.

1294

The first municipal constitution was confirmed in 1294 by Duke Rudolf. The citizens paid high taxes to their permanently bankrupt rulers, but were granted certain privileges and rights in return.

The Rise of Court and Municipality

Until 1300

The dukes furthered the expansion of Munich by providing land. It was the responsibility of the citizens to build their new town wall, however, even though the dukes supported them with a portion of the taxes that were levied at the town gates. The Wittelsbach rulers promoted the development of a number of monastic orders in Munich, such as the Franciscans in 1257 or the Augustinians in 1294. These monastic buildings determined the appearance of the town considerably. By 1300 the population of Munich had grown to 5000.

1384

With the expansion of the town, the castle was now surrounded by houses on all sides and no longer on the edge of the town. This was considered a problematic situation in times of conflict with the citizens. The rulers therefore began erecting a new, impregnable castle in the north-east corner of the new town wall, the so-called Neuveste, which was surrounded by a moat. They thus created a separation within the town between the rulers and the citizens. The earlier castle and ducal residence, from now on referred to as the Alter Hof, was now used to house members of the growing entourage and later for ducal administration.

1470

The economic centre for the citizens was the Schrannenplatz, today Marienplatz. It was taken for granted, that this square was also used for courtly events such as knights tournaments. From 1470 the Munich citizens erected their own dance hall, a building that is today known as the Altes Rathaus. This burghers' hall, too, was used for ducal festivities such as marriages or tributes of the estates of the realm.

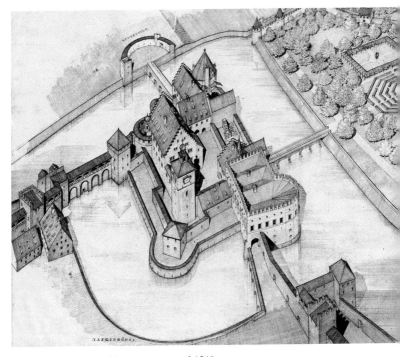

Reconstruction of the Neuveste around 1540

1493

Hartmut Schedel wrote about Munich in his *Weltchronik* in 1493:
"Munich, situated on the River Yser, is famous among the princely
residences in German lands and the most substantial of Bavarian
towns."

1505

Munich was declared the capital of the whole of Bavaria in 1505.
The town was thus not only a princely residence town, but also the
administrative centre of Bavaria. This important step in the devel-
opment of the town of Munich is owed not least to the sovereign
himself.

1570

The ducal power was further demonstrated in a true-to-scale model of the town made by Jakob Sandtner in 1570 by commission from Duke Albrecht V. It shows the town shortly before it became the main ducal residence, the "Princely Town of Munich". From this period on the citizens were gradually elbowed out – spatially as well as economically.

The Baroque Period and Absolutism – The conversion of Munich from a Burghers' Town to a Princely Residence

Until 1600

Large ducal building projects necessitated the demolition of a great number of citizens' houses. In Kaufinger Straße, for example, 34 houses had to give way to the construction of the Jesuit monastery and the Michaelskirche.

1618–1648

The town fortifications had to be renewed from 1619 onwards due to the threats during the Thirty Years War. Mighty ramparts now surrounded the town. The town itself was enlarged only by the Hofgarten. In order to master this enormous task, the duke once again recruited the citizens of Munich.

Within the walls, the town itself changed, too. There were fewer small allotments for the ordinary burghers, while the representational buildings of the court and the church took up more and more space – one quarter of the town. The royal household grew to 1000 people. There was such a shortage of living space, that the ordinary population were forced to add stories to their houses, or build new houses in the former gardens.

During the first half of the 17th century the former Neuveste was enlarged so considerably that it was no longer a fortified residence, but one of the most magnificent palace complexes of its time.

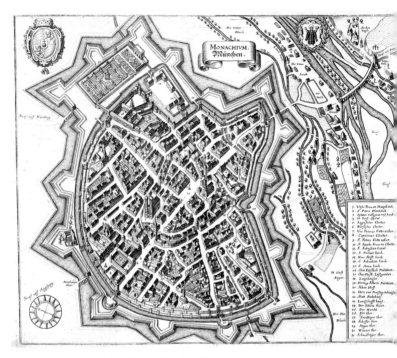

View of Munich by Matthäus Merian, 1644

1789

In 1789 Prince Elector Karl Theodor initiated the first development of land beyond the town wall: the Englischer Garten, a vast public park. In 1795 he made another decisive change for the development of the town: He stipulated that "Munich can and should no longer be a fortified town." The gates were gradually removed and the fortifications demolished. Views of Munich of this period show the town surrounded not by walls, but by countryside.

By the end of the 18th century the population of Munich had grown from 10,000 to 40,000, while the expanse of the town had remained largely unchanged since the Middle Ages.

Secularisation and Classicism – Expansion of the Town in Line with the King's Representational Requirements

1800–1850

The density of buildings within the fortified town is clearly evident, while the generous spaces around the court form a strong contrast to the densely populatetd town centre and even exceed size of the town's old central square. In order to establish a spacious square in front of the residence (Max-Joseph-Platz), an thus to achieve a revaluation of this area, the medieval Franciscan monastery had to be demolished.

1806

When Bavaria was made a kingdom in 1806, Munich became the centre of state administration. The population grew by 25,000 to 65,000 citizens within a period of only 25 years. As early as 1808 the King had a new development laid out to the north of the town, the Maxvorstadt around Carolinenplatz. The royal capital's representational functions increased in this period. The new sub-urbs Max- and Ludwigsvorstadt were therefore planned with a grid layout, with new main roads leading in a straight line to the residence. Thus the King defined a new town centre: the Royal centre.

1825–1848

No other ruler determined the appearance of Munich more than Ludwig I. His primary concern were the arts and architecture. Ludwig believed that the international recognition of Bavaria depended on the magnificence of its capital. His town planning served his monarchic image of the town as the seat of the sovereign and the arts, rather than functionality.

His reign from 1825 to 1848 saw the construction of a number of monumental buildings, such as the two Pinakotheken, the Propyläen and the Glyphothek, some of which had to be partly financed by the commune (e.g. the Ludwigskirche). When Ludwig I planned his new Ludwigstraße, which was to be lined with rep-resentational Classicist buildings, most of the new "Vorstadt" buildings along Schwabinger Landstraße had to be levelled again

only few years after their construction. The Residence itself was changed and enlarged in line with Ludwig's notion of monarchic representation to include the "Festsaalbau" and the "Königsbau". By 1850 the population of Munich had doubled to 120,000 citizens.

Bourgeois Munich – Industrialisation, City Growth and Emancipation of the Bourgeoisie

1850 – 1900

The town of Munich was governed by the King until the mid 19th century. It was not until the communal reforms in 1869 that the citizens were given more freedom. Furthermore, monarchic town planning was neglected in the city after the reign of Ludwig I. The main changes in this period resulted from the industrialisation: trade and industry grew to such an extent that the historic town centre soon became too small. From the mid 19th century private economic interests – rather than royal interests – determined the development of new areas beyond the historic town walls.

The incorporation of surrounding villages and suburbs considerably enlarged the historic town. Au, Giesing and Haidhausen

Ludwigstraße, coloured lithograph, around 1865. Original in the Munich Municipal Museum

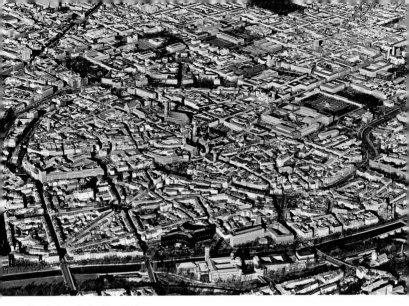

Aerial view of Munich, 1983

were incorporated in 1854, Ramersdorf, Untersendling, Neuhausen, Schwabing and Bogenhausen in 1864–1892. The population quadrupled in the period from 1850 to 1900 to 490,000, the city area tripled in size.

Historic burghers' houses were demolished to make room for Gründerzeit buildings – banks, beer halls or department stores – in the town centre. This presentation of a modern capital was now no longer monarchic, but bourgeois. It reflects the tremendous economic success of the Munich bourgeoisie during the Industrialisation.

1918

The revolution of 1918 ended the reign of the Wittelsbach dynasty in Bavaria. The residence of the dukes and kings was opened to the public as a museum in 1920.

The reconstruction of Munich after the Second World War was a combination of preserving the historic appearance of the town and modernisation. The population of Munich first exceeded one million in the late 1950s.

Fortification of the Town and the Castle

The Alter Hof, the seat of the Bavarian duke and town sovereign was situated in the north-east corner of the first Munich town wall on an elevation west of the Isar (the so-called Old Town Terrace). It was oriented towards Schwabing, the first domain to pass from the Freising Bishops into the hands of the Wittelsbach family.

The fortifications of the town and the castle were probably built in the same period: The oldest surviving castle wall has been dated by archaeologists to the late 12th century. Its construction compares with the town wall of the same period. The walls consist of an outer shell of brick filled with layers of plaster and Isar pebbles. An additional safety feature of the Alter Hof was a 3-metre deep and 11-metre wide ditch towards the town, which was only

Exposed section of the old castle wall

The construction of the wall segment equals that of the old Munich town wall in the late 12th century: two brick walls, with a

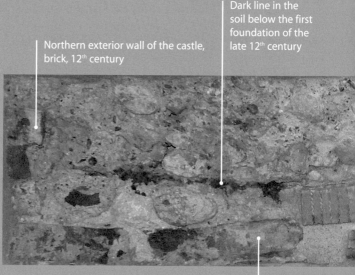

Northern exterior wall of the castle, brick, 12th century

Dark line in the soil below the first foundation of the late 12th century

Later foundation, dating from the period when another storey was added to the Burgstock, around 1460/70

filled-up towards the end of the 14th century to create additional building space.

When Ludwig the Severe declared Munich the centre of administration of the Duchy of Upper Bavaria, the Alter Hof was enlarged and a second entrance was probably created in the south towards the town, approximately where the Gate House stands today.

Countless ducal administrators settled in 'Purchstrazz'. The second town wall, which was begun during his reign, considerably enlarged the walled area of the town, so that the Alter Hof was now more in the town centre than at the edge.

The Neuveste was erected by the Dukes from 1384 as a water castle in the north-east corner of the second town wall. This castle was gradually enlarged and became the Wittelsbach family residence from the 16th century on. It was now the centre of government for the whole of Bavaria.

layer of mortar and Isar pebbles between them. Later conversions of the building have left their traces.

The southern exterior wall of the castle was levelled in the 19th century when the small cellar room was built

Filling material inside the double castle wall: Isar pebbles, stones and a lime mixture

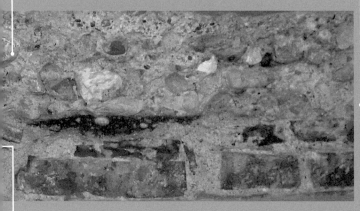

Bricks inserted in 2000 – 2003 to stabilize the wall

Salt disc from
the salt mine in
Berchtesgaden

Economy and Trade

The establishment of a market at the old 'villa munichen' on the intersection of the trade routes from north to south and east to west and the construction of a bridge across the Isar in the 12th century reflected imperial and ducal economic interests: Munich was becoming a lucrative centre of long-distance trade. The precious salt came from the east, Wine and metal came from the south. Cloth arrived from the north.

The dukes of the house of Wittelsbach supported trade considerably: They granted the town the privilege of the so-called stacking and route dictate, which gave Munich a monopoly as a transit town and trading centre for all salt transports from Reichenhall to the west. These trade charters, from which Munich tradesmen profited as much as the ducal sovereign, were respected by the Duchy until 1587. After this date, the new territorial state took over the coordination of trade and paid fixed sums of money to the burghers.

The interdependence of the court and the burghers extended in another direction, too: In the 14th and 15th century the dukes often took out loans from wealthy citizens or improved their financial situation by levying municipal law taxes and other taxes. In turn, many burghers benefited from the proximity to the court, which they supplied with all the necessary goods. In the 13th century, the burghers and the duke jointly financed the Heiliggeistspital as a shelter and lodge for the poor in the growing town of Munich.

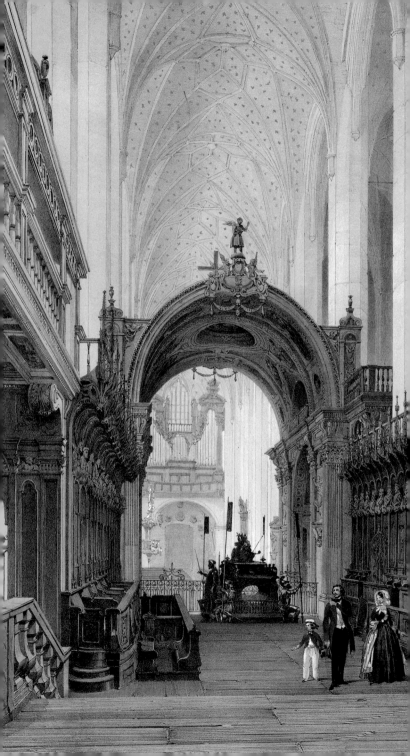

Church and Dynasty in Munich

The Peterskirche was one of the first pastoral churches in the town. The sovereigns presumably had their own private chapel in the Alter Hof. A second parish church became necessary in 1271, as the town had grown tremendously. This privilege was bestowed on the Frauenkirche. In the course of the expansion of the Alter Hof and the town, the Wittelsbach sovereigns also converted an older shrine of the Virgin Mary into a church. This was motivated by dynastic interests: Ludwig the Bavarian buried his first wife Beatrix here in 1322 and donated an Emperor Altar in 1331 as well as an Imperial Holy Mass.

Emperor Ludwig himself was buried here in 1347, followed by countless relatives. The Frauenkirche thus became a family burial place and a true royal church within the town. The dukes tried in vain to elevate the Frauenkirche to a bishop's cathedral. They did, however, succeed in achieving the status of a princely collegiate church in 1494.

The Wittelsbach sovereigns continued expanding their ances- tor's tomb. In the 17th century they even moved it to a central loca- tion in the choir, beneath the newly erected Benno Arch, where it stood until the 19th century.

Ducal sponsorship since the 13th century also benefited a number of orders, which had settled in Munich, such as
• the Augustinians in Neuhauserstraße (around 1290)
• the Franciscans (1257), who were later located north of the Alter Hof and provided a number of outstanding intellectuals in the period of Ludwig the Bavarian
• The Order of Poor Ladies in Anger (1284), which was home to a number of female members of the Wittelsbach family.

Tomb of Ludwig IV beneath the Benno Arch
in the Munich Frauenkirche, aquatint, 19th century

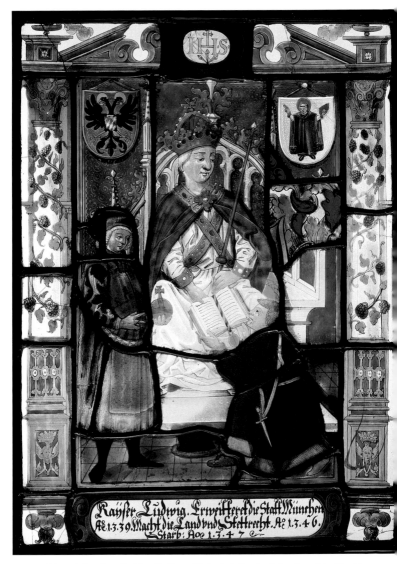

Glas window from the Munich Frauenkirche depicting the declaration of the Munich town law, 1st half 17th century. Original in the Bayrisches Nationalmuseum, Munich

Town Supremacy

Munich's growth before 1158 from a settlement to a centre of trade with a bridge, a customs office and the coining prerogative was owed to the reign of the Bavarian Duke Henry the Lion. The town's early days were still determined by competition with the Bishop of Freising and his Föhring Market.

The town rights – and with them also the profits – were shared between the Duke and the Bishop. While the Wittelsbach dynasty were able to strengthen their position, the Bishop's power declined during the 13th century. At the same time, the growing class of burghers began claiming certain rights.

A municipal council is mentioned for the first time in 1286. In 1294 the burghers even obtained their first town right from Duke Rudolf. At first the burghers were represented only by high-ranking officials serving the nobility, but during the 14th century more and more tradesmen and craftsmen joined the town council. An 'Outer Council' was formed in addition to the 'Inner Council' to provide these social climbers with a say in communal administration.

In 1340 Emperor Ludwig considerably expanded the town rights of the Munich burghers. Fiscal dominion, high jurisdiction and other important rights, such as the right to appoint town councillors and the claim to assistance from the burghers during war times, remained with the Wittelsbach sovereigns.

They clearly demonstrated their position as town rulers by using municipal premises for their own purposes: The Municipal Dance House, today's Old Town Hall, was used to host ducal visitors, for wedding celebrations and as the venue for the burghers' municipal oath of allegiance to the Duke. This is why the magnificent decoration in the Old Town Hall largely refers to the Wittelsbach dynasty.

Town Emblem – Town Coat of Arms – Town Colours

The symbols in the Munich emblem and the coat of arms reflect the close links between the town and the sovereign. The figure of the monk in the town gate refers to the earliest mention of a market near 'munichen' in 1158: Munich was founded on a site that had been settled by monks from Schäftlarn Abbey. The eagle indicates that between 1180 and 1240

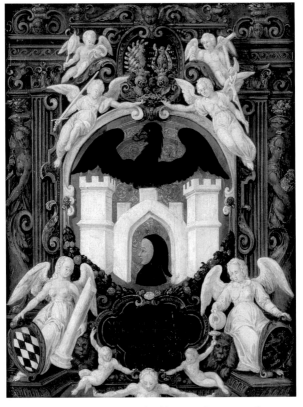

Baroque painting (1606) depicting the oldest Munich town coat of arms of 1239/1249. Original in the Munich Municipal Museum

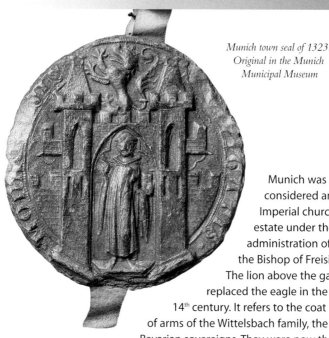

*Munich town seal of 1323.
Original in the Munich
Municipal Museum*

Munich was considered an Imperial church estate under the administration of the Bishop of Freising. The lion above the gate replaced the eagle in the 14th century. It refers to the coat of arms of the Wittelsbach family, the Bavarian sovereigns. They were now the sole potentates in Munich. They furthered their residence town and expanded it.

The colours of the Holy Roman Empire – gold (yellow) and black – where introduced in the 15th century to commemorate the reign of Emperor Ludwig the Bavarian.

Large Munich coat of arms

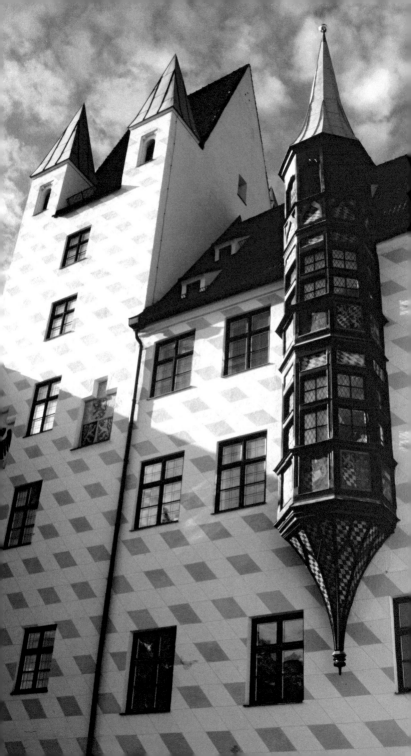

THE ALTER HOF

The Beginnings of the Alter Hof: From a Castle to an Upper Bavarian Ducal Palace

The Alter Hof, the oldest residence of the Bavarian rulers in Munich, is 800 years old. It was a four-sided castle complex situated on an elevation above the Isar at the northeastern edge of the town. Excavations uncovered the remains of a large stone building and two wooden houses of the 12th century, probably farm buildings and workshops. There was also a blacksmith's shop. A gate tower and another stone building were added at a later date.

The castle in Munich was one of several residences of the Dukes of Wittelsbach, who ruled Bavaria since 1180 when Emperor Barbarossa enfeoffed the Duchy of Bavaria to Count Palatine Otto. Munich gained significance after the division of the Duchy into Upper and Lower Bavaria in 1255: It became the centre of administration and the seat of government of the Upper Bavarian Duchy under Duke Ludwig II the Severe (1253–1294). His oldest son, Rudolf I (1294–1317), also reigned from his Munich residence: many documents were issued by his officials here.

The Golden Age under Ludwig IV: From an Imperial Castle to a Representational Palace

The Alter Hof experienced its golden age in the 14th century. It was the favourite residence of Duke Ludwig IV, who was elected king in 1314 and crowned emperor of the Holy Roman Empire in Rome in 1328. The ward was transformed into a representational building and a larger church, the Margarethenkapelle, later Lorenzkapelle, was built. The imperial insignia were kept here for 26 years. The official administration and the archive were also housed in the castle during this time.

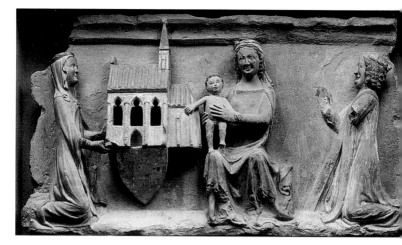

Donor relief from the St. Lorenzkapelle in the Alter Hof, 1324.
Original in the Bayerisches Nationalmuseum, Munich

Bavaria was split up again after the death of Ludwig in 1347 and ruled by several dukes simultaneously. A 'new house', four other stone buildings, battlement walks, kitchens, bath houses and a large heated hall date from this period. By now the town had grown so large that the Alter Hof was in the middle of town. An uprising among the citizens made the dukes build a new castle at the north-eastern edge of the town in 1384, the so-called Neu-veste. It was thus a new, safe place for the ducal family. The main residence, however, was still the Alter Hof.

The Alter Hof was converted once again under the dukes Sigmund and Albrecht IV around 1460/70. Another floor was added to the gate tower, the façades were decorated and the interiors elaborated. The two Wittelsbach dominions Lower and Upper Bavaria were finally reunited in 1505.

The Alter Hof in Munich thus became the residence of the reunited duchy of Bavaria.

A New Appearance – A New Role: The Alter Hof as a Centre of Administration and Economy

The Wittelsbach dynasty systematically expanded their territorial dominion and soon needed a modern residence as a visible sign of their power. The Neuveste was thus gradually transformed into a new representational ensemble. The Duke moved his court to what is today the Munich Residence in the first half of the 16th century.

The Alter Hof remained the residence of members of the large ducal family and their guests. Above all, however, it was the seat of all the important administration offices such as the fiscal office and the councils. The new, lucrative ducal brewery 'Braunes Brauhaus' also stood here from 1589 to 1808.

Bavaria became a kingdom on 1.1.1806. The administration and government were completely reformed and only the state fiscal office remained in the Alter Hof. Dilapidated parts of the building were demolished (Lorenzkapelle 1816) and replaced by larger administration buildings (customs and tax registry offices). The Alter Hof complex has recently been restored and partly rebuilt (2003) to provide space for a number of state cultural institutions, businesses as well as private apartments.

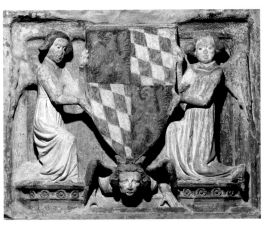

Coat of arms of Bavaria-Palatinate held by angels, from the St. Lorenzkapelle in the Alter Hof, 1324. Original in the Bayerisches Nationalmuseum, Munich

The Functions of the Alter Hof after the Construction of New Residence

Apartments for the Family and Guests

Until the 16th century the Alter Hof was the royal residence and the seat of the government. After the move to the new residence around 1550, family members and honoured guests of state resided in the Alter Hof until the end of the 16th century.

Fiscal Administration

The highest state fiscal offices were housed in the Alter Hof for nearly 500 years. In 1581 the king's fiscal office was given a separate building, the Pfisterstock. In 1960 the tax office moved into the Brunnenstock, which was demolished in 2004 and rebuilt in 2006.

Archive

Official documents were issued and kept in the state office. They were administered by a councillor, who sat in the Pfisterstock from the 16th century. These documents form the core of the Bavarian State Archive.

Library

Duke Albrecht V bought important collections of books. In 1599 the court library was housed in the Hofkammergebäude (Pfisterstock). The approx. 11000 volumes, magnificent manuscripts, globes and scientific instruments were also available to scholars. They form the nucleus of the Bavarian State Library.

Jurisdiction

A number of legal offices resided in the Alter Hof from around 1550, including the highest state legal instances.

Hofbräuhaus

Beer was brewed in the Alter Hof for more than 200 years. The first court brewery was initiated by Wilhelm V in 1589. It was built at the east edge of the castle complex right next to the Pfisterbach. Beer was brewed in the Alter Hof until 1808 and the Bockbier was served in the famous Bockkeller.

Armoury

The armoury in the Pfisterstock is where the suits of armour and the weapons were stored before a great fire destroyed this wing on 22 July 1578.

Wine Cellar

The cellars beneath the Alter Hof were used for storage purposes and looked after by a cellar master and his servants. Until the 19th century the princely wine cellar was housed in the Zwingerstock. Wine is still served here today.

The Alter Hof – A Chronology

Late 12th century / around 1200

Four-winged castle complex at the top of a slope within the first town wall with a largish stone building on the town wall and two timber-frame buildings, probably utility buildings and workshops. First access road from the West near the present access from Dienerstraße.

1st half 13th century

Construction of a gate tower in the South and a wing in the West with an adjacent wooden building (Burgstock)

1324

Consecration of the Margarethen-/Lorenzkapelle

1324 – 1350

The Imperial insignia are kept in the chapel

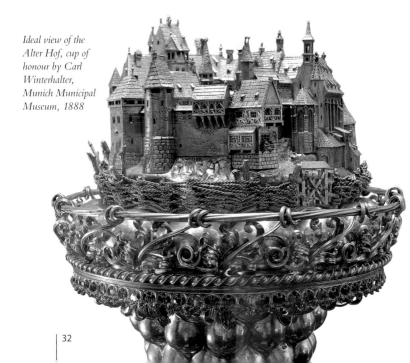

Ideal view of the Alter Hof, cup of honour by Carl Winterhalter, Munich Municipal Museum, 1888

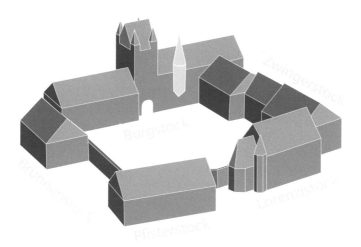

14 February 1327

A third of the town and parts of the ducal castle (wooden buildings?) are destroyed in a fire.

1359–1364

Four other stone buildings are documented in this period as well as: a "new house", knights' Hall, kitchen, bathrooms, rampart walk along the exterior wall of the chapel

around 1460/70

Enlargement of the Burgstock and the Zwingerstock: Addition of another storey to the gate tower, "Affenerker" (Monkey Oriel) and hall with wood-panelling, hall with genealogical murals, vaulted cellar

1563–1567

Construction of the "Alte Münze" by Wilhelm Egckl as a stable and to house the art collection, linked to the Alter Hof by a passageway

22 July 1578

A fire destroys the court mill, the bakery and the harness room in the Pfisterstock.

1579 – 1581

Construction of the three-storeyed Pfisterstock which houses the library, the stables and the fiscal administration. The architect was Wilhelm Egckl.

1589

Construction of the "Braunes Brauhaus" (first court brewery)

1816 – 1819

Demolition of the Lorenzkirche, construction of the Lorenzistock (customs office), removal of parts of the southern gate tower in 1813

1829 – 1832

Reconstruction of the Brunnenstock by G. F. Ziebland – fiscal administration, tax office

1902 – 1903

Reconstruction of the Brunnenstock by Heilmann/Littmann

1944

Destructions in World War II (Brunnenstock and Lorenzistock)

1957/58 and 1959 – 61

Demolition and reconstruction of the Pfisterstock and Brunnenstock

1966/68

Reconstruction of the gate tower

2000 – 2003

Renovation of the Zwinger- and Burgstock, which now house a number of state cultural institutions

2004 – 2006

Demolition and reconstruction of the Brunnenstock and Pfisterstock (Auer + Weber). A modern building is erected above the site of the Lorenzistock (Prof. Kulka).

The 19ᵗʰ Century Legend of the Monkey Tower

Legend reports that a tame monkey was allowed to roam around the court of the Bavarian dukes. One day a pig managed to escape the servants and ran into the chamber of the youngest child, the future Emperor Ludwig, who lay alone in his cot. Just as the pig was about to grab the baby, the monkey snatched the infant from its cot and climbed out through the window and up the tower. There he bared his teeth and rocked the baby in his arms, with the courtiers watching in horror from below. Some time later the monkey climbed down again calmly and laid the baby back in his cot.

Afterwards, a figure of a monkey was placed on the roof of the torret of the Lorenzkapelle to commemorate the prince's rescue. After the destruction of the Lorenzkapelle in 1816, the legend was applied to the "Monkey Oriel" on the Burgstock.

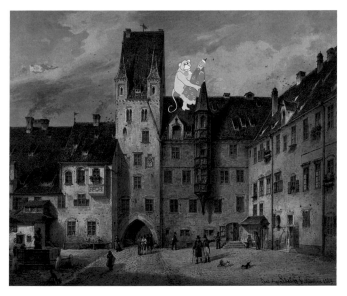

Still from the multimedia presentation in the exhibition "The Imperial Castle in Munich"

LUDWIG 'THE BAVARIAN'

The most important resident of the Alter Hof was Emperor Ludwig IV of the House of Wittelsbach (1282–1347). His rule was determined by his power struggle with the Pope. His contemporaries described him as engaging, affable, clever, but also as erratic and unpredictable.

Ludwig was the second son of Duke Ludwig 'the Severe' of Upper Bavaria and the Palatinate and his Habsburg wife Mechtild. He was born in 1282, probably in the Alter Hof in Munich. In 1301 he won a dispute against his elder brother and thus earned the right to rule the state as a duke. He was the first member of the Wittelsbach family to be elected king in 1314 and crowned emperor of the Holy Roman Empire in Rome in 1328. Both these titles were disputed, however. The Popes even disputed all of Ludwig's titles and excommunicated him several times. Pope John XXII referred to him unfavourably as 'the Bavarian'.

Portrait of Ludwig IV, initial of a document for the town of Passau, 1345

Intended as an insult, it became the characteristic epithet for Ludwig after his death in 1347.

On his return from Rome in 1329 he signed the Agreement of Pavia with his relatives in the Palatinate, which was to stabilize the dominion of Bavaria.

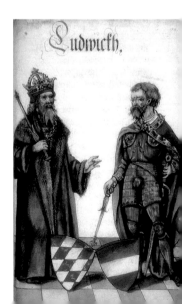

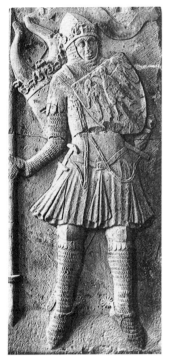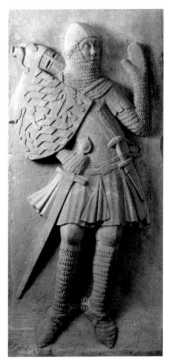

Ludwig IV (left) and Rudolf I, reliefs from the Elector Cycle of the Mainz Kaufhaus, around 1320/30

Ludwig did not only have enemies in his Empire, however: he protected a number of famous academics, who wrote treatises against the church at his court in Munich.

Ludwig travelled much during his reign, but he always enjoyed spending time in Munich. To emphasize the legitimacy of his royal title he had the imperial insignia (Crown, Holy Lance, Sceptre, Orb, gowns, relics) brought to the Lorenzkapelle in the Alter Hof. For 26 years they gave magnificence to the court and the town.

The Imperial Insignia

The Imperial insignia are a number of items such as the crown, the sceptre and the orb, as well as gowns and clerical treasures, which were the symbols of power. Whoever owned these items and presented them was considered the legitimate ruler. His power was legitimated by the Grace of God. During the reign of Ludwig IV the Imperial insignia were kept in the Lorenzkapelle in the Imperial castle and displayed on special occasions. Thousands would travel to Munich to see this treasure, a journey which would grant them absolution from their sins.

During the reign of Ludwig IV the Imperial insignia were:

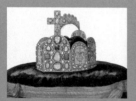

Ottonian Imperial Crown

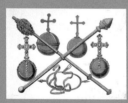

Imperial Sceptre and Imperial Orb

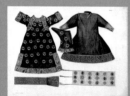

Eagle dalmatic and stole

Coronation Gowns

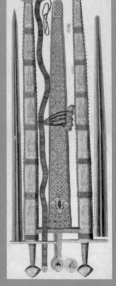

Imperial Sword (left and right) and ceremonial sword (centre)

• Sabre of Charlemagne • Imperial Cross • Holy Lance • Relics, including a tooth of St. John the Baptist

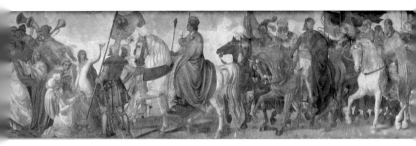

Triumphal procession of Ludwig IV after his victory in the Battle of Mühldorf in 1322.
Fresco commissioned by King Ludwig I for the Isator, Bernhard von Neher, 1835

The Death and Afterlife of Ludwig

Emperor Ludwig died after a reign of 33 years in 1347 while hunting near the monastery in Fürstenfeld without having been granted absolution. The emperor had been excommunicated by the Pope and had no right to be buried in a consecrated space. He was still buried in the Munich Frauenkirche, though. In the course of time his successors had his tomb turned into a magnificent monument.

Throughout the centuries the image of Ludwig was used by the Bavarian rulers to justify their own political ambitions. Countless paintings, sculptures, coats of arms and monuments on churches, palaces and squares commemorated Emperor Ludwig and served as a general reminder of the long history and European significance of the Wittelsbach dynasty.

The modern view of Ludwig's rule is determined above all by the long and fierce dispute between him as a king and emperor and the Popes, in which he managed to assert the independence of the worldly rule in the empire against the Curia.

Ludwig's rule was a very successful one in terms of Bavarian politics. When he died he left a magnificent and dynastically peaceful nation with important new territories in the Netherlands, Tirol and the Mark Brandenburg. His successors were unable to preserve this status, however.

"Wahre Abbildungen der sämtlichen Reichskleinodien",
Johann A. Delsenbach, coloured engravings, 1790

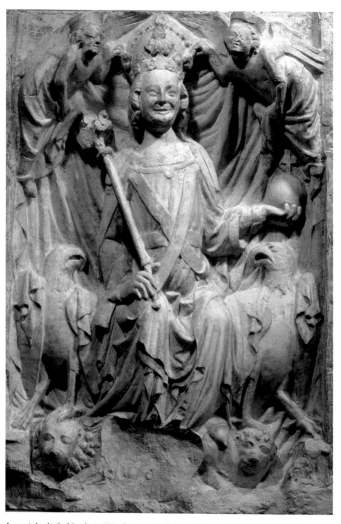

Imperial relief of Ludwig IV, plaster cast of a sandstone relief of 1332–1340, around 1868

Ludwig the Bavarian – A Glossary

A Agreement of Pavia
This agreement in 1329 clarified the relationship between the Bavarian and Palatinate branches of the Wittelsbach family and the dynastic line of succession.

Alter Hof
The Alter Hof in Munich: Ducal residence, Imperial Castle and Ludwig's favourite residence. Probably also the place where he was born in 1282.

B Battle of Mühldorf
The Battle of Mühldorf, in which Ludwig conquered his anti king Frederick of Habsburg, called Frederick 'the Beautiful', took place on 28 September 1322.

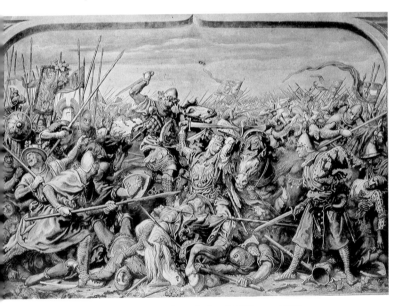

The Battle of Mühldorf in 1322, Lithograph, Joseph Widmann, 1902

Birth
Ludwig was born in Munich in 1282, probably in the Alter Hof.

Burial Site

Even though he was excommunicated by the Pope, Ludwig was still buried in the Munich Frauenkirche, alongside his wife Beatrix.

C Character

Ludwig was considered perseverent, a competent soldier, frequently erratic in his decisions. He is described as an affable, benevolent person, who loved dance and food.

D Death

Ludwig died on 11 October 1347 of a heart attack while bear-hunting in Puch near Fürstenfeldbruck. He never reconciled with the Pope.

Dynastic Power

As a duke, from 1301, and as an emperor, from 1328, Ludwig always sought unity, stability and increasing power for the Wittelsbach dynasty: reunification of Upper and Lower Bavaria in 1340.

E Election

On 20 October 1314 five electors elected Ludwig King in Frankfurt. Other electors arranged a parallel convention on 19 October 1314 and elected Frederick 'the Beautiful' anti-king. Ludwig was crowned "in the correct place", Aachen, on 25 November 1314.

Emperor

Ludwig was crowned Emperor of the Holy Roman Empire in 1328 in Rome.

Excommunication

In the years from 1324 to 1346 the Pope issued several pronouncements of excommunication against Ludwig and his followers, one of the worst church punishments in the Middle Ages. Ludwig was excommunicated nine times. The Pope even denied Ludwig all rights of rulership and referred to him derogatively as "the Bavarian".

F Franciscans

A number of prominent Franciscan scholars such as William of Occam and Marsilius of Padua supported Ludwig in his dispute

Portrait of Ludwig IV, Jacopo Amigoni, around 1726–28

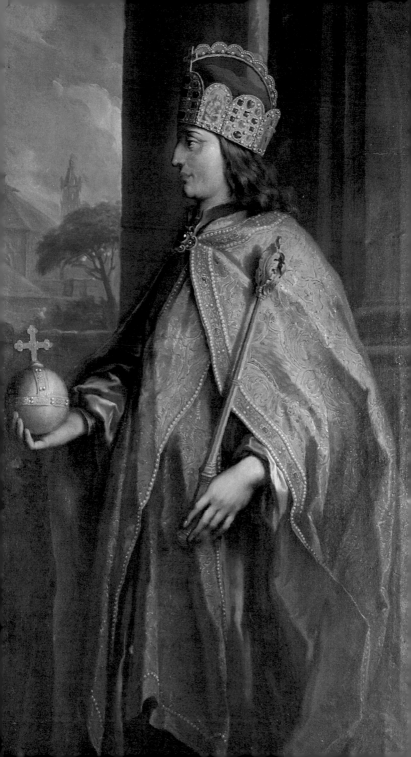

with the Pope. After their excommunication they were given shelter in Munich.

G German

During Ludwig's reign German gradually replaced Latin as the official language of documents.

I Insignia

The possession of the Imperial insignia, which were kept in the Alter Hof from 1324 to 1350, was the visible sign of Ludwig's right to the Throne.

K King

Ludwig was elected king in Frankfurt in 1314. His anti-king from 1314 to 1322 was his cousin Frederick the Beautiful.

L Luxemburg Dynasty

The Luxemburg dynasty, alongside the Habsburg dynasty one of the most important ruling families in Europe, competed with the House of Wittelsbach for the throne. They supplied many of Ludwig's supporters, such as King John of Bohemia, but also opponents such as his son, King Charles IV.

M Marriage

Ludwig's first wife was Beatrix of Silesia, whom he married in 1309 (?) (6 children). He married his second wife, Margaret of Holland in 1324 (10 children).

Munich

The town prospered under Ludwig's particular support.

Munich Agreement

In 1325 Ludwig appointed his former rival Frederick 'the Beautiful' his co-king.

N Nuremberg

Nuremberg, Frankfurt and other Imperial towns enjoyed Ludwig's support. Ludwig visited Nuremberg frequently.

P Parents

Ludwig IV's father was Duke Ludwig II (1229 – 1294) 'the Severe' of Upper Bavaria and Count

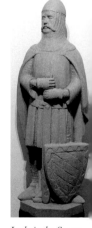

Ludwig the Severe

Palatine near Rhine. He was attributed the epithet "the Severe" after he erroneously accused his wife Maria of Brabant (*1226) of having committed adultery and had her executed in 1256. He atoned for his terrible deed by founding Fürstenfeld Abbey (Fürstenfeldbruck). His third wife Mechthild Mathilde of Habsburg (1251–1304) was the mother of Emperor Ludwig IV.

Popes in Avignon

The Popes moved their seat of residence to Avignon in 1309. In his striving for independence of his worldly power from the Church, Ludwig had three powerful opponents: John XXII (1316–1334), Benedict XII (1334–1342) and Clement VI (1342–1352). Ludwig therefore supported the election of an antipope in Rome: Nikolaus V (1328–1330).

R Residences

As a travelling sovereign, Ludwig had a number of residences throughout the empire.

Rome

After his coronation with the Lombard crown in Milan in 1327, Ludwig travelled on to Rome (1327–1330).

S Support

A number of monasteries were granted privileges and support by Ludwig: Ettal Monastery (1330) and Fürstenfeldbruck monastery.

T Territorial Gains

During his reign Ludwig succeeded in gaining considerable territories for his family: Brandenburg 1323–1373, Tyrol 1342–1369, Holland 1345–1425/33.

U Upper Bavarian Statute Book

The Upper Bavarian Statute Book, issued in 1346, controlled civil, penal and procedural issues in upper Bavaria for many centuries.

Y Youth

Ludwig spent his youth at the court of his Habsburg relatives in Vienna. His cousin and friend Frederick 'the Beautiful' later became his most avid opponent (1313).

Ludwig the Bavarian – A Chronology

1282 Birth of Ludwig

1294 Death of Ludwig's father, Duke Ludwig II. He is succeeded by his first born son Rudolf I (02.02.)

1294 Marriage of Ludwig's brother Rudolf (01.09.)

ca. 1300 Sojourn at the court in Vienna

1304 Death of Ludwig's mother, Mechthild of Habsburg (23.12.)

1309 Betrothal to Beatrix of Silesia-Glogau

1301 Rudolf accepts Ludwig as the co-ruler of Bavaria/Palatinate (20.07.)

1310 Partition of Upper Bavaria, Ludwig reigns independently (01.10.)

1312 Death of Duke Otto III, Ludwig is appointed guardian of the youthful rulers of Lower Bavaria (09.09.)

1313 The Munich Peace Treaty reverses the 1310 partition of the state (21.06.); Death of King Henry VIII (24.08.); Count Palatine Rudolf defects to the Habsburg side; Battle of Gammelsdorf against Austria under Frederick 'the Beautiful' (09.11.)

1314 Election of Ludwig IV as German King (20.10.); Coronation in Aachen (25.11.)

1315 Munich is granted various privileges

1317 The contract with Rudolf makes Ludwig the sole ruler of Bavaria and the Palatinate

1319 The duke abolishes the Munich "Ungeld"

1322 Death of Queen Beatrix (24. 08.); Victory over Frederick 'the Beautiful' at Mühldorf (28.09.)

1323 Ludwig hands over the Mark and Electorate of Brandenburg and Pomerania to his son; Beginning of the Papal court case against Ludwig (8.10.); Ludwig appeals at court in Nuremberg (18.12.)

1324 Marriage of Margaret of Holland in Cologne (25.02.); First excommunication of Ludwig (23.03.); Ludwig's first appeal against the excommunication and the accusations in Sachsenhausen (22.05.)

1324–50 The Imperial insignia are kept in Munich

1325 "Trausnitzer Sühne" (Penance of Trausnitz) (13.03.); Munich agreement with Frederick 'the Beautiful' (05.09.)

1326 Marsilius of Padua seeks refuge in the Munich royal palace

1327–39 Journey to Italy

1327 Ludwig is crowned with the Langobard Crown in Milan (31.05.)

1328 Ludwig is crowned Emperor in St. Peter's in Rome (17.01.); Pope John XXII deposes Ludwig (18. 04.)

1328 Second coronation of Ludwig by the antipope Nicholas V (22.05.)

1329 Agreement of Pavia (04.08.)

1330 Death of Frederick 'the Beautiful' (13.01.); Foundation of the knights' collegiate in Ettal (28.04.)

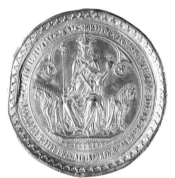

The Golden Bull of Emperor Ludwig IV, seal, 1327/28

1332 Munich is granted the salt trading privilege

1337 Completion of the Isartor and the town fortifications

1338 Common Law of Rhens (16.07.); Imperial law "Licet iuris", Koblenz Reichstag

1339 Ludwig reconciles with the lower Bavarian duke Heinrich the Elder (16.02.)

1340 Ludwig ceremoniously confirms the codification of the Munich town law; Reunification of Lower and Upper Bavaria

1342 Betrothal of his son Ludwig to Margaret of Tyrol (10.02.)

1345/46 Inherits the territories Holland, Seeland and Hennegau from his second wife Margaret of Holland

1346 Upper Bavarian State Law (07.01.); last Papal excommunication of Ludwig (13.04.); Election of Charles of Luxemburg, Margrave of Moravia as (anti-)king (11.07.)

1347 Death of Ludwig (11.10.)

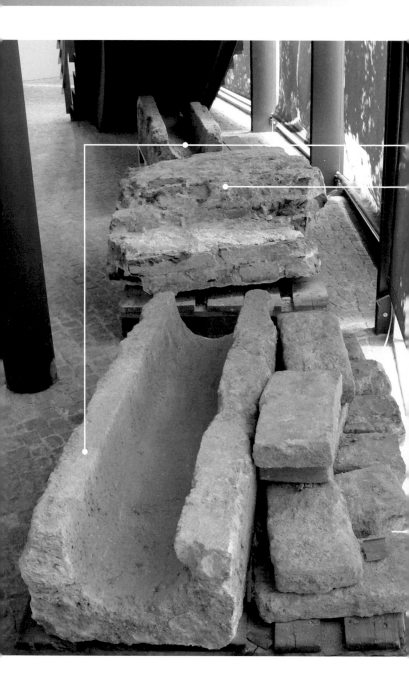

FINDINGS

STONE FRAGMENTS AND EXCAVATED
ITEMS FROM THE ALTER HOF

____ Tuff drainpipes from the ducal bathroom
or the kitchen, 16th century

____ Fragment of a brick wall from the former
Braunes Brauhaus (brewery), 1590

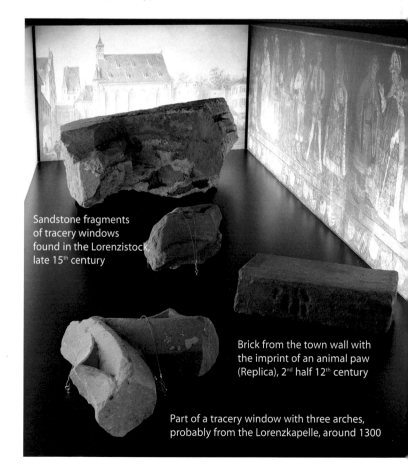

Sandstone fragments
of tracery windows
found in the Lorenzistock,
late 15th century

Brick from the town wall with
the imprint of an animal paw
(Replica), 2nd half 12th century

Part of a tracery window with three arches,
probably from the Lorenzkapelle, around 1300

Metal findings discovered during archaeological excavations in 2004 in the area of the cloth hall and the tailor's shop. A large fire on 22 July 1578 completely destroyed this part of the building.

Lead seal from a bale of cloth

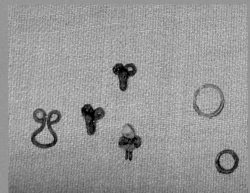

Bodice hooks and eyelets

Ear spatula, part of a toiletry set

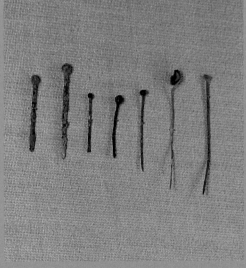

Needles

Two metal lumps from the area of the cloth hall. A fire in 1578 melted metal objects, needles, rings and a coin together with soil and stones to form such lumps.

Remains of a ›Nuppenbecher‹, a cup also referred to as ›Krautstrunk‹. Mouth-blown glass, Germany around 1500

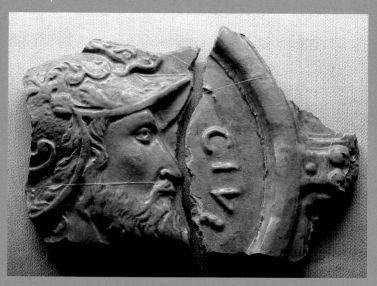

Remains of a green stove tile with an image of the Roman Emperor Claudius, probably southern Germany, mid 16th century

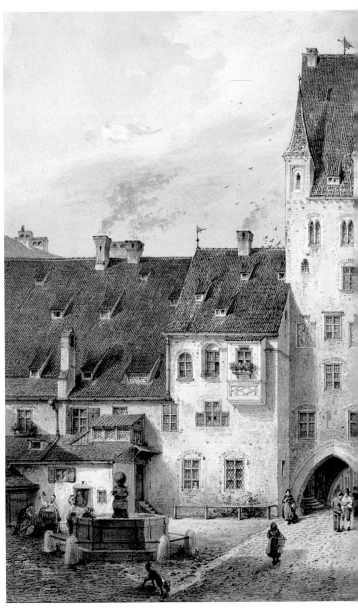

View of the Alter Hof, Carl August Lebschée, 1869.
Original in the Munich Municipal Museum

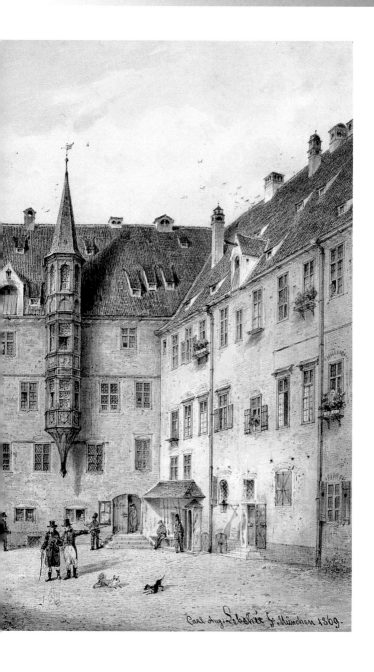

Carl Aug. Lebschée f. München 1869.

MÜNCHNER KAISERBURG
ALTER HOF

An exhibition of the Landesstelle für die nichtstaatlichen Museen in Bayern for the Free State of Bavaria

Under the patronage of
H.R.H. Prince Luitpold of Bavaria

Project Coordination
Dr. Hannelore Kunz-Ott,
Landesstelle für die nichtstaatlichen Museen

Project Coordination Design
Dipl.-Ing. (FH) Eva-Maria Fleckenstein,
Landesstelle für die nichtstaatlichen Museen

Academic Concept
Dr. Uta Piereth | Ursula Eymold

Media and Design Concept
Michael Hoffer | Ursula Eymold

Technical Planning and Realisation
P.medien

Academic Consultants
Dr. Richard Bauer, Stadtarchiv München | Dr. Christian Behrer, Büro für Denkmalpflege, Regensburg | Dr. Johannes Erichsen, Bayerische Verwaltung der staatlichen Schlösser, Gärten und Seen, Munich | Dr. Michael Henker, Haus der Bayerischen Geschichte, Augsburg | Karl Schnieringer, Bayerisches Landesamt für Denkmalpflege

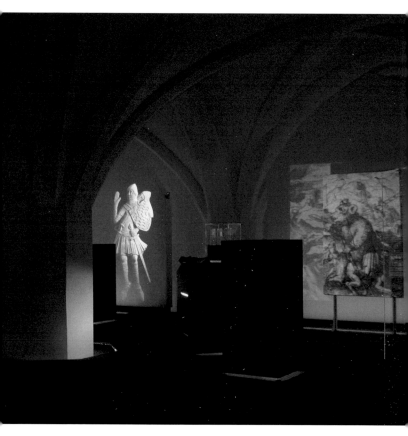

Alter Hof – the exhibition "The Imperial Castle in Munich"

We would particularly like to thank our supporters and partners:
Bayerische Landesstiftung
Kulturstiftung der Stadtsparkasse München
Kreissparkasse München Starnberg
König Ludwig GmbH & Co KG Schlossbrauerei Kaltenberg
Betten Rid Company

The photographic material was kindly provided by
Landesstelle für die nichtstaatlichen Museen (Lisa Söllner), Munich:
 Front cover bottom, front cover inside, page 16/17, 18, 32, 44, 48,
 49, 50, 51, 55
Niklaus Leuenberger, Weßling: Front cover bottom, page 26
Michael Hoffer, Büro für Gestaltung, Munich: page 2/3, 6, 30, 31
Bayerische Verwaltung der staatlichen Schlösser, Gärten und Seen,
 Munich: page 10, 43
Staatliche Graphische Sammlung, Munich: page 12
Bayerisches Landesamt für Denkmalpflege, Munich: page 15
Münchner Stadtmuseum, Munich: page 14, 24, 52/53
Archiv des Erzbistums München und Freising, Munich: page 20
Bayerisches Nationalmuseum, Munich: page 22, 28, 29, 40
Stadtarchiv München: page 25 top
Landeshauptstadt München: page 25 bottom
P.medien, Munich: page 33, 35, rear flap outside
Stadtarchiv Passau: page 36 top
Landesmuseum Mainz: page 37
Bayerische Staatsbibliothek, Munich: page 36 bottom
Germanisches Nationalmuseum, Nuremberg: page 38
Baureferat der Landeshauptstadt München: page 39 (high resolution
 photogrammetric frieze documentation. © ArcTron 3D GmbH,
 www.arctron.de)
Haus der Bayerischen Geschichte, Augsburg / Stadtarchiv Mühldorf am Inn:
 page 41
Bayerisches Hauptstaatsarchiv, Munich: page 47

Compilation
Susanne Stettner M.A. and Sabine Garau M.A.

Translation
Kerstin Hall, Penzberg

Layout and Production
Edgar Endl

Typography
Margret Russer, Munich

Reproduction
Lanarepro, Lana (South Tyrol)

Printing and binding
F&W Mediencenter, Kienberg

Bibliographic information published by the Deutsche Nationalbibliothek
The Deutsche Nationalbibliothek lists this publication in the Deutsche
Nationalbibliografie; detailed bibliographic data are available in the
Internet at http://dnb.d-nb.de.

ISBN 978-3-422-06839-1
© 2008 Deutscher Kunstverlag GmbH München Berlin